MW00574316

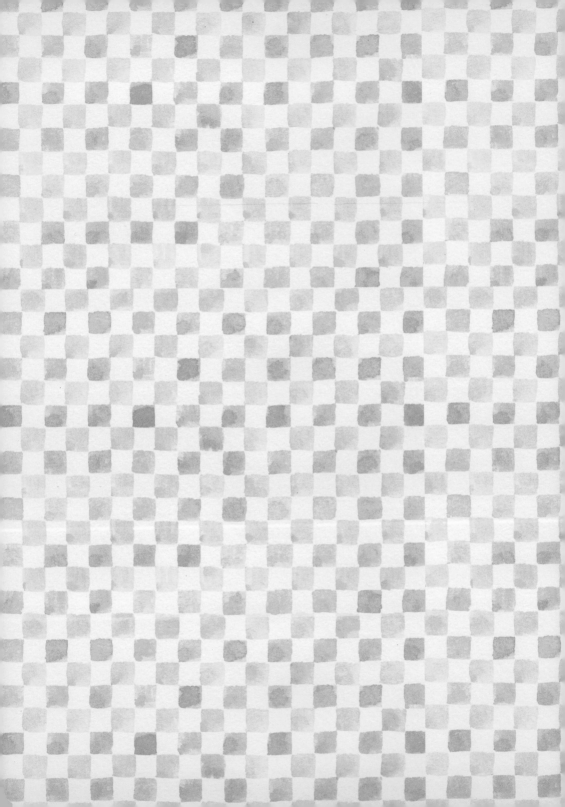

Harry Potter™

DOT JOURNAL

Property of

HOW TO USE
This Journal

THIS MAGICAL DOT JOURNAL can be anything and everything you need to plan, track, and organize your life. The dotted pages provide a blank slate that you can fully customize according to your needs. With just a pen and a ruler, this time-saving journal can become a diary, planner, to-do list, calendar, and sketchbook—whatever you need to lead your best, most intentional life!

ORGANIZING FOR SUCCESS

Everyday life can get extremely busy. From daily errands to healthy habits to important events, there's a lot to keep track of. Specially designed to be the perfect tool for bullet journaling, this journal counterbalances the chaos by offering a flexible template to organize your life. Use the dotted pages to create spreads to help you track and record your tasks, events, notes, reminders, and more. The index pages in the back enable you to create a table of contents so you can easily go back and find the content you need, while the key helps you record your bullets and other notations.

Need a little inspiration? Check out the sample layouts in the next few pages. Copy them exactly or use them as a starting point to create your own spreads. Then it's all up to you!

CONJURE YOUR CREATIVITY

All you need to keep this journal is a pen and maybe a ruler. (Check the back pocket!) But why limit yourself? Feel free to decorate and embellish your spreads with markers, stickers, washi tape, sticky notes, paper clips, binder clips, and whatever else strikes your fancy. Just remember: Don't worry if it's not perfect. Mistakes are part of life, and this journal is all about making your life better, not about making it perfect.

Have fun!

Monday

SEPTEMBER 8TH

TOP TO-DO'S

- ● 10 a.m. soccer practice
- ☒ 2 p.m. chemistry quiz
- ○ 7 p.m. prep cupcakes for Jamie's party

GROCERIES

- ○ milk
- ○ eggs
- – yogurt
- – veggies
- – fruit
- – granola

ACTION ITEMS

Borrow camera from Violet

LITTLE THINGS

Look up how to make photo props

Talk to Nick about Saturday

Tuesday

SEPTEMBER 9TH

TOP TO-DO'S

GROCERIES

ACTION ITEMS

LITTLE THINGS

Monday 8

- 10 a.m. soccer practice
- 2 p.m. chemistry quiz
- 7 p.m. prep cupcakes for Jamie's party

Tuesday 9

Wednesday 10

- 11 a.m. doctor appointment

Thursday 11

Friday 12

Saturday 13

- 3 p.m. coffee with Mark

Sunday 14

- grocery shopping

Notes

WEEK OF SEPTEMBER 8-14

September

MONDAY	TUESDAY	WEDNESDAY
1	2	3
8 chemistry quiz	9 Florida trip	10
15	16 license expires	17
22	23	24
29	30 half marathon	

THURSDAY	FRIDAY	SATURDAY	SUNDAY
4	5	6	7
11	12	13	14
18 Jenny's birthday	19	20	21
25	26	27	28

Notes

104

168

Index

Index

Index

Key

Harry Potter ™

INSIGHTS

an imprint of

INSIGHT 👁 EDITIONS

www.insighteditions.com

MANUFACTURED IN CHINA

10 9 8 7 6 5 4 3 2 1